Picnics of New England

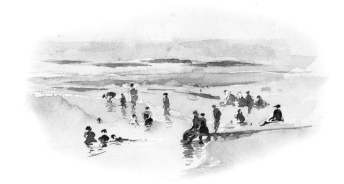

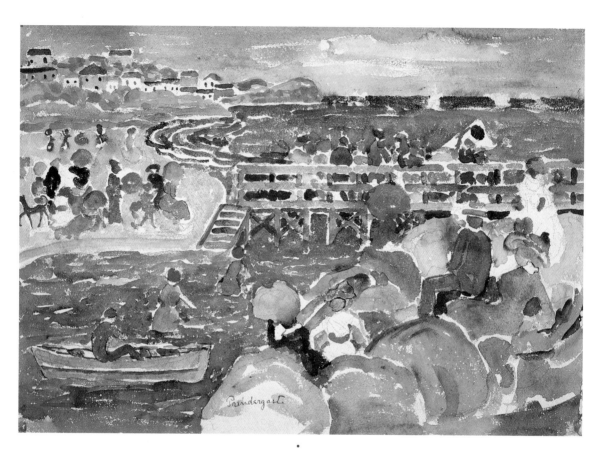

Long Beach, 1920–1923
Maurice Brazil Prendergast

Picnics of New England

With Recipes to Inspire and Paintings to Enchant

by CYNTHIA WHITNEY WARD

·

Introduction by Erica E. Hirshler
Picnic illustrations by Lisa Canney Chesaux

MUSEUM OF FINE ARTS, BOSTON

For Rhoda, Jack, Charles, and Michael

Cover illustration
LIGHTHOUSE AND BUILDINGS, PORTLAND HEAD,
(Cape Elizabeth, Maine), 1927
Edward Hopper, *American, 1882–1967*
Watercolor, 13½ x 19½ inches
Bequest of John T. Spaulding
48.723

•

First published in the United Sates of America in 1997
by the MUSEUM OF FINE ARTS, BOSTON
Department of Retail Publications
295 Huntington Avenue
Boston, Massachusetts 02115

•

Introduction © 1997 ERICA E. HIRSHLER
Text © 1997 CYNTHIA WHITNEY WARD
Picnic illustrations © 1997 LISA CANNEY CHESAUX

•

10 9 8 7 6 5 4 3 2
ISBN 0-87846-442-5

Designed by Emily Betsch
Printed in Korea

Contents

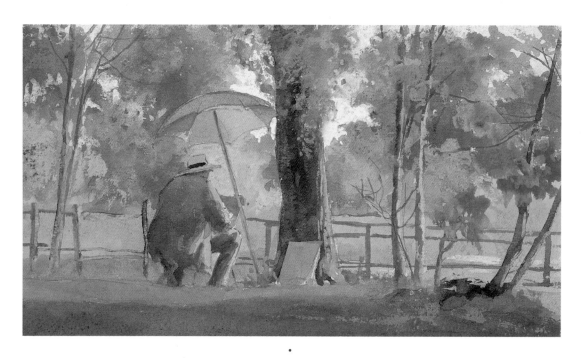

AN ARTIST SKETCHING, *probably* 1880–1890
James Wells Champney

Introduction

By the mid-nineteenth century, the American landscape (formerly regarded as a danger and a threat) had become an emblem of our national culture. Painters and poets described its divinity, and devoted themselves to the study of nature. Artists helped to establish the popularity of some of New England's most beloved destinations: the coast of Maine, the White Mountains of New Hampshire, the Rhode Island shore. Inspired by their images and lured by the new ease of transportation, Americans put into practice social theorist Herbert Spencer's 1882 pronouncement: "We have had somewhat too much of the 'gospel of work.' It is time to preach the gospel of relaxation."

During the 1880s and 1890s, Americans placed a new cultural emphasis on leisure. Public holidays were established, working hours were shortened, and more time for recreation was available. Medical experts proclaimed that open-air activities were necessary for physical and mental health, and organized sports, outdoor games, and gardening clubs flourished. As the concept of a summer vacation became widespread, country retreats multiplied, offering a variety of experiences from rustic camps for would-be hunters and fishermen to luxury resorts with every amenity.

For painters, summer was a working season. While the winters were scheduled with exhibitions, sales, and studio work (often portraits), the summer was a time of freedom and experimentation, an interval when painters could devote themselves to their art. "I was very glad indeed to

reach this place," wrote Dennis Bunker from Medfield, Massachusetts in July 1890. "I see a thousand things to paint at once." While some artists, like Bunker, preferred to work alone, other painters preferred companionship, and returned year after year to one of the many artists' communities that developed throughout New England. Theodore Robinson, one of America's earliest Impressionists, refined his style in his native Vermont, while Childe Hassam and his fellows created an Impressionist paradise on the island of Appledore, off the New Hampshire coast. In Maine, the Boston painter Charles Woodbury founded a summer school at Ogunquit, while other students gathered in Cos Cob, Connecticut, Ipswich and Gloucester, Massachusetts, and Matunuck, Rhode Island. New Hampshire's White Mountains, where the landscape painter Thomas Cole had first traveled in 1826, continued to provide aesthetic inspiration, while new art colonies developed in the southern part of the state in the pastoral towns of Cornish and Dublin. There the many outdoor picnics and masquerades planned by summer residents—including the painters Abbott Thayer and Thomas Dewing and the sculptor Augustus St. Gaudens—became the highlights of the summer season. The Cornish sculptor Frances Grimes recalled that the "artists [were] usually interested in food." She described "long tables loaded with food, whole salmons, hams, and quantities of salads, ice cream, and cake," and noted that the artist Herbert Adams said "women should be careful what they wore to picnics; it made such a difference; they should wear white or bright colors."

These pleasures of New England's palate and palette are renewed in the following pages. We invite you to recreate them in your own favorite places and to enjoy this selection of culinary treats.

—ERICA E. HIRSHLER
Assistant Curator of American Paintings

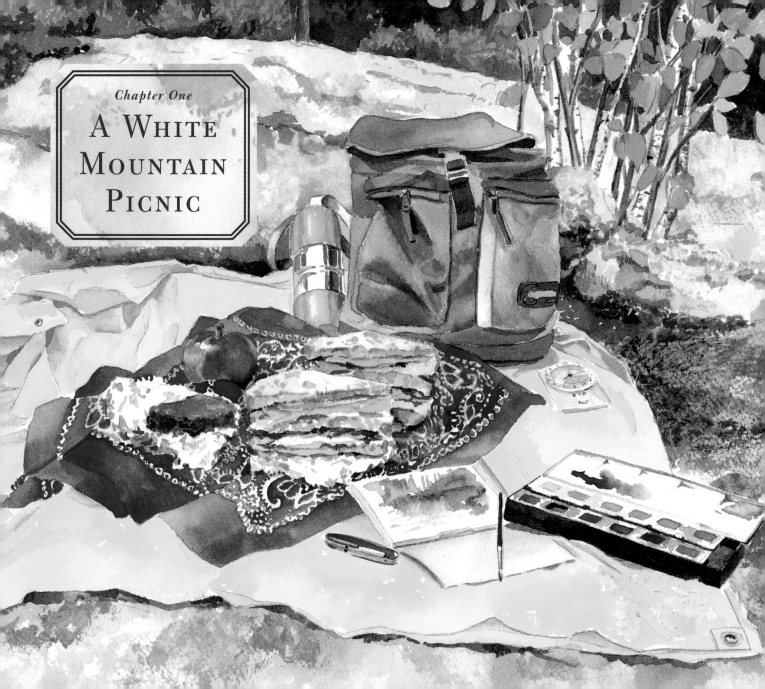

Chapter One

A White Mountain Picnic

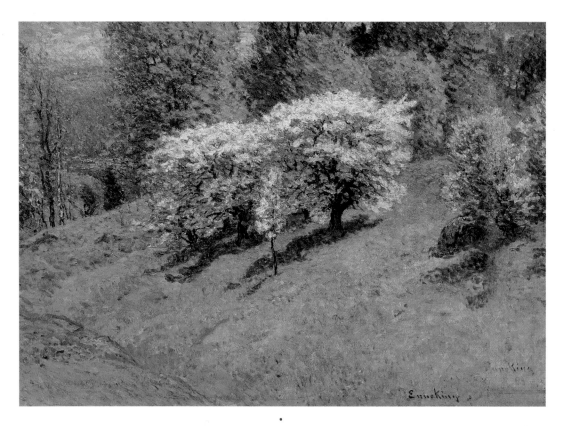

SPRING HILLSIDE, 1899–1902
John Joseph Enneking

A WHITE MOUNTAIN PICNIC
A Trek, A Treat, A Treasure

I wish that I had had the pleasure of meeting my great, great grandfather John J. Enneking, but I have been able to do so only through his paintings, sketchbooks and the anecdotal stories that have passed my way. I do know, however, that he was smitten with the White Mountains of New Hampshire, and would vanish quite happily into them, for weeks at a time, emerging with a cache of unfinished canvases that would keep him occupied all winter long.

He would sketch grazing sheep and meadows and babbling brooks, capturing all the glorious colors and moods that are New Hampshire. He would climb his beloved mountains to paint the perfect moment of sun and cloud and shadow. When he found that vista, nothing could dislodge him, even the black bear that appeared one day out of nowhere, frightening Enneking's two companions down the mountain. Well after dark and hours after the bear sighting, Enneking ambled off the mountain and calmly told his two astonished friends that they needn't have worried,

MENU

A HEARTY
CHEDDAR CHEESE SANDWICH
With savory relish on toasted raisin bread

·

AN APPLE
The perfect complement to cheese

·

CHOCOLATE BROWNIES
Hidden WOW *centers are a special treat*

·

GREEN TEA
Bracing and thirst quenching

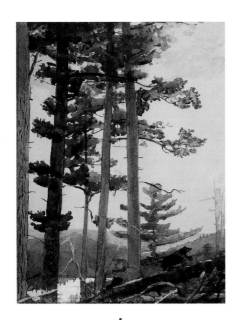

OLD SETTLERS, 1892
Winslow Homer

INGREDIENTS
A good local cheddar cheese,
 sharp or mild
Branston Pickle Relish
Lettuce
Raisin toasting bread

the bear didn't get in the way of his view. Winslow Homer, who worked in the White Mountains in 1868, was more familiar with the bears of the Adirondack wilderness, and included two in his watercolor, *Old Settlers.*

Our White Mountain picnic menu is a tribute to Enneking, who no doubt traveled lightly as he painted his way through every peak and valley of those glorious mountains.

A Hearty Cheddar Cheese Sandwich

New Englanders have a fondness for pickles and often demand them in unlikely combinations, such as clam chowder and pickles or doughnuts and pickles. A sweet and savory pickle relish is the secret ingredient in this mouthwatering sandwich. First, prepare lightly toasted raisin toast for as many sandwiches as you will require. Use a toasting bread rather than a thinly sliced tea bread to prepare the foundation for this hearty sandwich. Slightly undertoast the bread if not eating immediately.

Spread one side of a piece of toast with Branston Pickle Relish, available at most grocery stores. Layer on sliced cheese and lettuce, and spread the final slice of toast with butter. Cut in half and wrap well in aluminum foil.

Chocolate Brownies with WOW Centers

When combined with a splendid New Hampshire day, these simple but decadent brownies are unbeatable. The secret is the layer of chocolate candy that you tuck into the center before they are baked. If you have a tried-and-true brownie recipe, use it. If not, use a prepared brownie mix or try this recipe—it's easy and delicious.

To make the brownie batter, melt chocolate and butter together in a double boiler, or a heavy bottomed pan, over low heat. Stir in sugar, then beat in eggs one at a time, adding vanilla last. Combine dry ingredients and add to pan. Stir until well combined.

Whether using a mix or this recipe, pour half the batter into a 8" x 8" greased pan, and layer 2 to 3 caramel-filled chocolate bars on top. Place the candy so it is evenly spaced and keep slightly away from the edges. Cover with the remaining batter and bake at 350° for approximately 25 to 30 minutes or until the brownies spring back to the touch. Let cool before cutting. Makes 8 to 12. Wrap in aluminum foil for hiking. A sweet surprise awaits you when you take a bite. WOW!

INGREDIENTS
4 squares unsweetened chocolate
1 cup unsalted butter
2 cups granulated sugar
4 eggs, beaten
2 teaspoons vanilla
1 teaspoon baking powder
1 cup flour
Dash of salt
Two or three 5-oz.
 caramel-filled chocolate bars

Green Tea

You'll want to take plenty of plain water on your hike, but for a special treat add a small thermos of green tea. Green tea can be enjoyed hot or at room temperature; it has very little caffeine but is bracing and delicious.

To prepare, warm a teapot, pour 2 cups of boiling water over one Japanese green teabag, let steep 5 minutes, and decant into a warmed thermos.

SETTING THE MOUNTAIN PICNIC SCENE

You can make this a true Enneking picnic by packing a few items to capture the moment-by-moment splendor of your day. A sketchbook and colored pencils, a small watercolor box and block of paper, or a camera would do nicely. Pair your renderings with words and you'll have a delightful memento of your day. If you are a gatherer, bring along several baggies and fill them with found forest objects: leaves, pine needles, bark and flowers can be pressed and made into delightful cards—especially when you add a description of the wonders that you saw that day in the mountains.

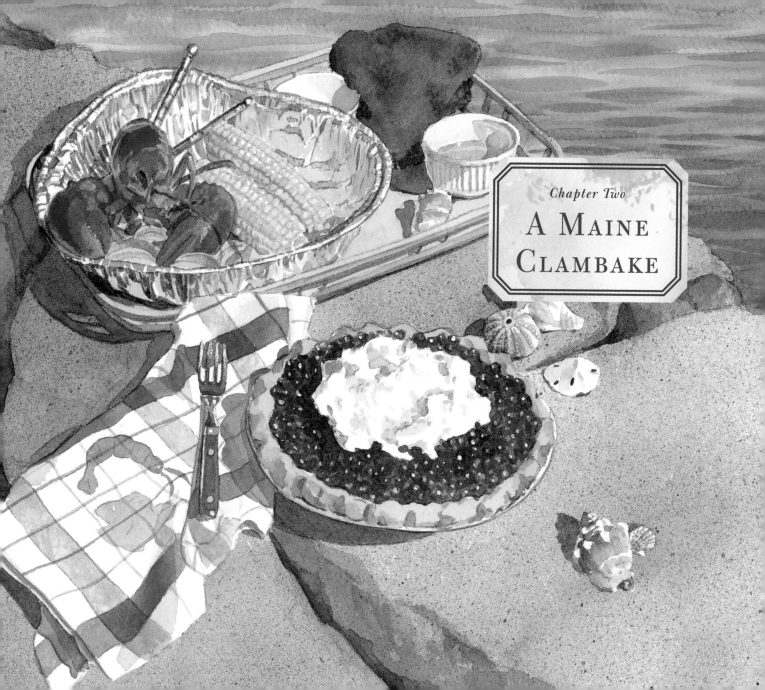

Chapter Two

A MAINE
CLAMBAKE

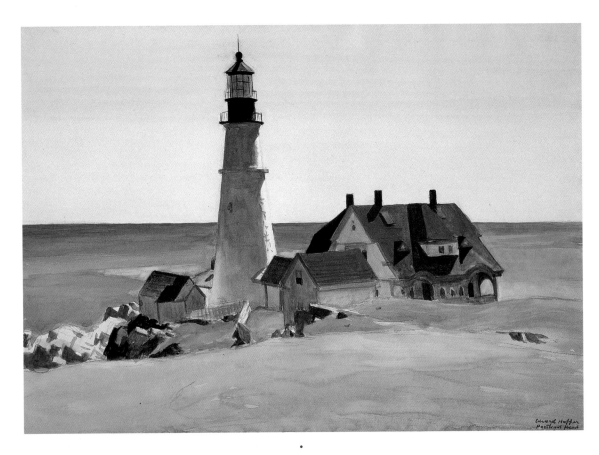

LIGHTHOUSE AND BUILDINGS, PORTLAND HEAD, *(Cape Elizabeth, Maine)*, 1927
Edward Hopper

A MAINE CLAMBAKE
Lighthouses and Lobsters

Maine. Just the name of this lovely state conjures up so many images. Picturesque towns and villages dot the rocky coast, each with its own personality and charm, and each filled with the prospect of wonderful adventures. Seaports abound with shops and museums that celebrate maritime history and the lure of the sea, while lighthouses draw visitors to their rocky perches. You can shop for smoked trout and salmon, seek out local crafts, hire a sloop, and listen to the marvelous Maine twang that sets these natives apart from everyone else on the planet. Fresh seafood is plentiful, but the quintessential ingredient is lobster. Indeed, to experience Maine heaven, you only need a bib, a lobster, and a view of the sea.

To create your own bit of heaven on earth, we've provided everything you need to create a wonderful lobster and clambake. Or, for an impromptu picnic with no fuss at all, just stop at one of the many clam shacks and purchase everything—steamers, lobster, corn—to go.

MENU

LOBSTER AND CHAMPAGNE
A traditional favorite with a new sauce
·
CHERRYSTONE CLAMS
A juicy and delicate taste of the sea
·
CORN ON THE COB
Pre-buttered and cooked in the husk
·
JANE'S FRESH MAINE
BLUEBERRY PIE
Fresh berries wrapped in blueberry sauce
and tucked in a pie crust

Ingredients
Clams (6 per person)
1- to 2-lb. lobsters (1 per person)
Corn on the cob (in husk)
Salt
Butter
Champagne

Clambake

A clambake can be held in a backyard, but the beach is highly recommended. First, check the tide schedule and choose your pit location accordingly. You will need shovels, large beach stones, heaps of seaweed, a large tarp, yards of cheesecloth soaked in seawater, a whisk broom, and lots of time and hands to help.

Dig a 4'x 4'x 2' rectangular pit. Lay large stones in the bottom, and build a wood fire directly on top of the stones. Keep this fire going by adding more wood for approximately 1½ to 2 hours, so that the stones underneath are very hot. Let the wood burn down (about 2 more hours or until the stones are red-hot). Brush away any embers before laying down the seaweed.

PREPARE THE FOOD:

Clams

6 per person. Clean clams by soaking and rinsing several times in buckets of cold water, or use salt water if at the beach. Lay the clean, unopened clams in single layers on big squares of cheesecloth. Fold cheesecloth over to contain clams.

Corn on the cob

2 ears per person. Soak corn in salted water for 1 hour. Peel back husks, remove silk, and sprinkle corn lightly with cayenne pep-

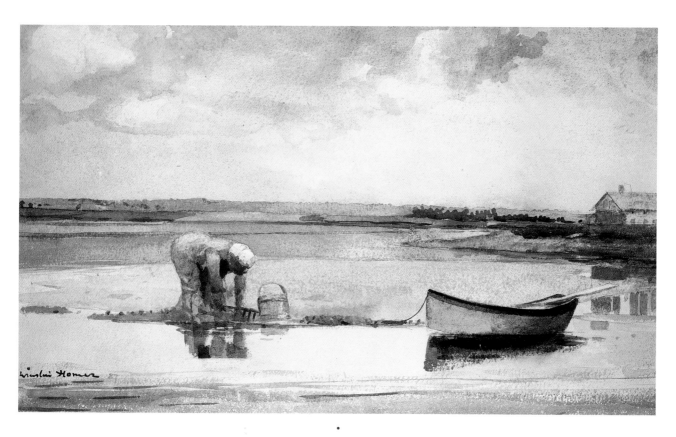

CLAMMING, 1887
Winslow Homer

per and dot with butter. Pull husks up and tie the open ends with twine.

Lobsters

One 1 to 2 pound lobster per person. Instead of the traditional drawn butter for dipping your cooked lobster, try champagne—it's a delicate and delicious alternative.

BEGIN:

Place a thick layer of seaweed—no less than 6" to 8"—directly onto the red-hot stones. Add the clams, then another layer of seaweed, though not as thick as the last. Add the corn, more seaweed, the lobsters (claws facing out), and a final layer of seaweed. Cover completely with a tarp, and weigh the tarp down with logs or stones or sand. Let this bake for 1 hour. If you want to add other foods, be sure to layer them according to cooking times—the more time required, the closer to the stones; less time closer to the top.

Jane's Fresh Maine Blueberry Pie

This easy-to-transport summer dessert combines the mouthwatering taste of fresh blueberries with a glaze of lightly cooked berries. While the fire is starting send your guests out to forage for the tiny and delicious wild blueberries that grow by the coast.

Cook in a saucepan, until soft, 1 cup blueberries and ¼ cup water. Put through a food mill and add ⅔ cup sugar, 2 tablespoons cornstarch, and 1 teaspoon cinnamon. Pour into saucepan and simmer for about 2 minutes until thick. Transfer this glaze to a bowl and chill.

When ready to serve, mix 3½ to 4 cups washed Maine blueberries with glaze and mound in a baked pie shell. Garnish with whipped cream dusted with cinnamon or serve with vanilla ice cream.

SETTING THE SCENE FOR A CLAMBAKE

To create fun invitations to your all-day party, find some plastic or paper lobster bibs and write your invitation on them with colored magic markers. Send these to your guests in large envelopes rubber-stamped with shell and starfish images. Perhaps you can even

INGREDIENTS

4½ to 5 cups tiny Maine blueberries
(if not available use regular blueberries)
⅔ cup sugar
2 tablespoons cornstarch
1 teaspoon cinnamon
Baked 9″ pie crust

Optional:
whipped cream or vanilla ice cream

find an appropriate sea-theme postage stamp for the mailing. To serve this feast, buy a dozen inexpensive rattan trays and simple oval serving platters to use as plates. The trays will easily hold platters, napkins, dipping sauces, silverware, nutcrackers, and picks and can be perched on a lap to help keep sand and other beach minutiae out of your food. My favorite napkins for messy picnics are washcloths. They are fabulous for drinking up drips, they come in great colors, and they wash up easily (no ironing!). Most importantly, be sure to have lots of empty containers handy for shells and husks that will be tossed during the course of the meal. The preparations for a clambake may sound daunting, but the tasty rewards and memorable experience are well worth the effort.

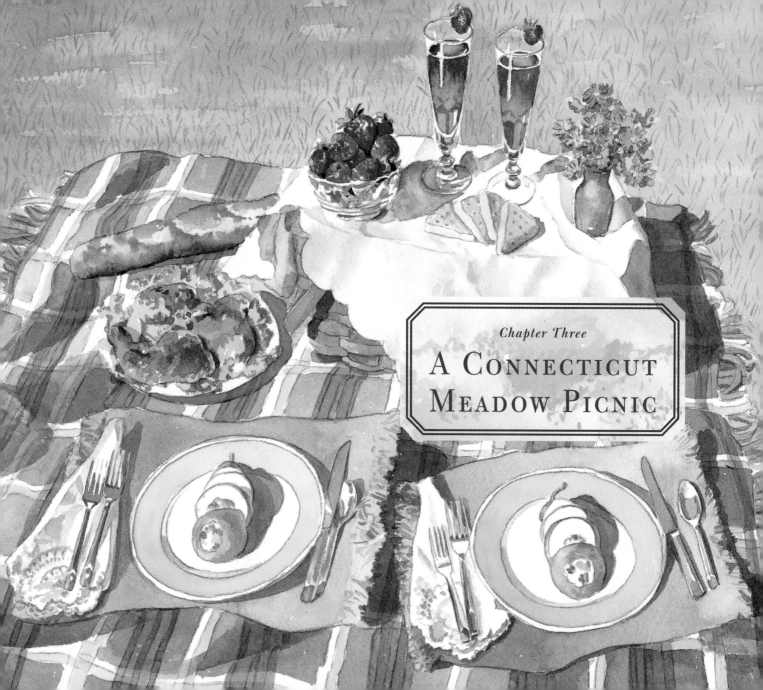

Chapter Three

A CONNECTICUT
MEADOW PICNIC

STUDY OF ELMS,
(*South Manchester, Connecticut*), 1866
Henry Roderick Newman

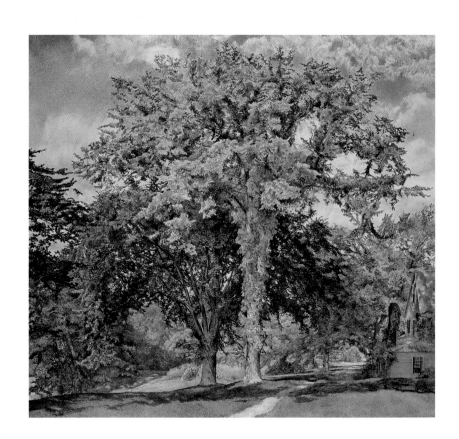

A Connecticut Meadow Picnic

A Romantic Picnic for Two

A weekend in Connecticut is a luxury, promising all sorts of delightful possibilities. In seaport towns you can explore specialty museums and tour stately old sea captains' homes. In the smallest villages you can discover intriguing antique shops and charming dooryard gardens. And from the rolling western hills you'll be within driving distance of outdoor concerts, dance performances, and wonderful summer theater.

If you wish to feel pampered, select a small inn or bed and breakfast. Each has its own personality and special offerings— homemade breakfast, afternoon tea, a glass of port in the evening. Your host can recommend a perfect meadow for a romantic picnic, and can probably supply you with that last-minute essential you forgot to pack in your hamper.

—+ ⊨ +—

MENU

PEARS WITH GORGONZOLA
AND PECANS
An elegant beginning

•

VANESSA'S ROSEMARY
AND LEMON CHICKEN
A succulent main course

•

CRUSTY FRENCH BAGUETTE
To mop up the sauce

•

A VARIETY OF TENDER LETTUCES
Because presentation is everything

•

STRAWBERRIES, SOUR CREAM,
AND BROWN SUGAR
So simple and so delicious

•

CRAN ROYALE
*New England's native berry
in a new guise*

2 Bosc pears
¼ lb. Gorgonzola (½ cup)
¼ cup toasted pecans, chopped

INGREDIENTS
1 whole 3- to 4-lb. chicken,
* with the back removed*
2 lemons, sliced very thinly
* (approximately 24 slices)*
1 whole head of garlic, peeled
* and separated into cloves*
6 whole rosemary sprigs
4 tablespoons olive oil
Kosher salt
Freshly ground pepper

Pears with Gorgonzola and Pecans

A delectable way to begin a romantic picnic. Choose two unblemished Bosc pears of the same size, preferably with stems attached. Using an apple corer, core each pear beginning at the bottom and stopping just below the top. Chop pecans and mix with Gorgonzola. Stuff mixture into pear cavities, wrap each pear in plastic wrap, and chill for at least 2 to 3 hours, or until cheese mixture is firm. Slice each pear horizontally into even slices, reshape if necessary, and rewrap in plastic for your picnic.

Vanessa's Rosemary and Lemon Chicken

Remove the back of the chicken and discard. Wash chicken and dry very well. Put lemon slices on the bottom of a roasting pan. Scatter cloves of garlic over lemon and cover with sprigs of rosemary. Dry the chicken one more time, and salt and pepper on both sides. Place skin side up on the rosemary bed and brush chicken with 2 tablespoons olive oil. Place in preheated 350° oven. The secret to this aromatic chicken dish is basting it every 20 minutes, first with olive oil, then with the pan juices. Roast for 1½ to 2 hours until the juices run clear and the skin is crispy. Cool. Remove fat from pan juices and strain, mashing garlic and

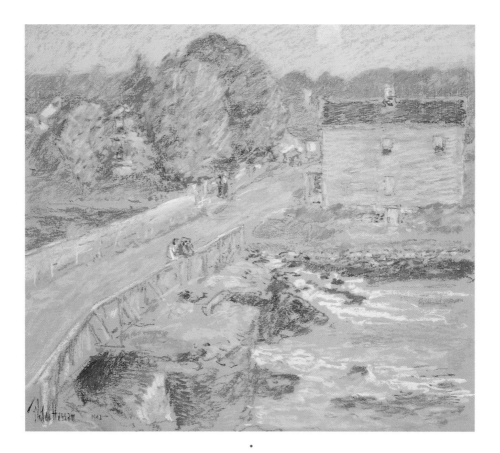

Cos Cob, 1902
Childe Hassam

removing rosemary. Reduce over low heat. Brush on slices of French bread for a tasty bruschetta, or serve as a sauce with your chicken. Serves 2, with possible leftovers.

Strawberries, Sour Cream, and Brown Sugar

I always presume that everyone knows about this simple but sublime dessert, until I present it and am greeted with new oohs and aahs. To prepare, hand pick strawberries of a uniform size—just right for a single bite—and leave the hull intact. In separate serving bowls, spoon the sour cream (vanilla or plain yogurt also works well) and brown sugar (crushed macaroons are nice, too).

Instruct your companion to dip a berry, first in sour cream and then in sugar, using the leafy green top as a handle.

Bring more strawberries than you think anyone can possibly eat, because they will be devoured.

Cran Royale

Pour a jigger of cranberry liquor into a champagne glass, fill with a dry or sweet champagne, and stir to combine. Place a fresh strawberry on the rim of each glass, and serve.

INGREDIENTS
*1 pint perfect strawberries,
hulls intact*
½ cup sour cream
¼ cup brown sugar

SETTING THE SCENE
FOR A ROMANTIC PICNIC

Proper wicker picnic hampers have always conjured up luxury and romance for me. They hold secrets that seem to unfold in unexpected and delicious ways. Connecticut's many antique shops could turn up a lovely vintage basket, or you can purchase a new one before you start. On this picnic, splurge—pack your fine china, silver, crystal, and linen. Include brightly colored napkins or dishtowels to wrap around plates and glassware for protection. Tightly lidded containers and double-bagging help prevent leaks. Your picnic hamper can get quite heavy, so pack accordingly. For extra storage, use a round wicker basket with a good strong handle. Individual ice packs will keep everything cool. For the perfect personal touch, bring along your favorite tapes and fresh flowers for your table.

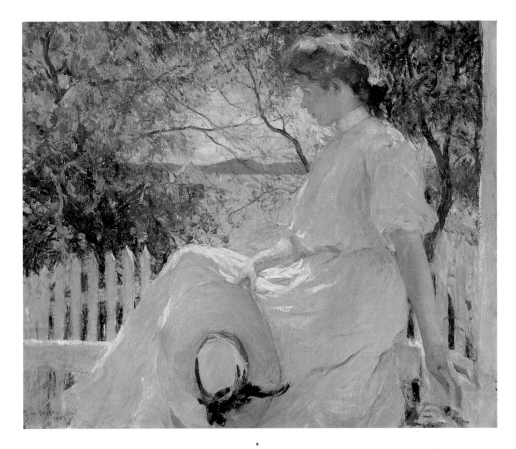

ELEANOR, 1907
Frank Weston Benson

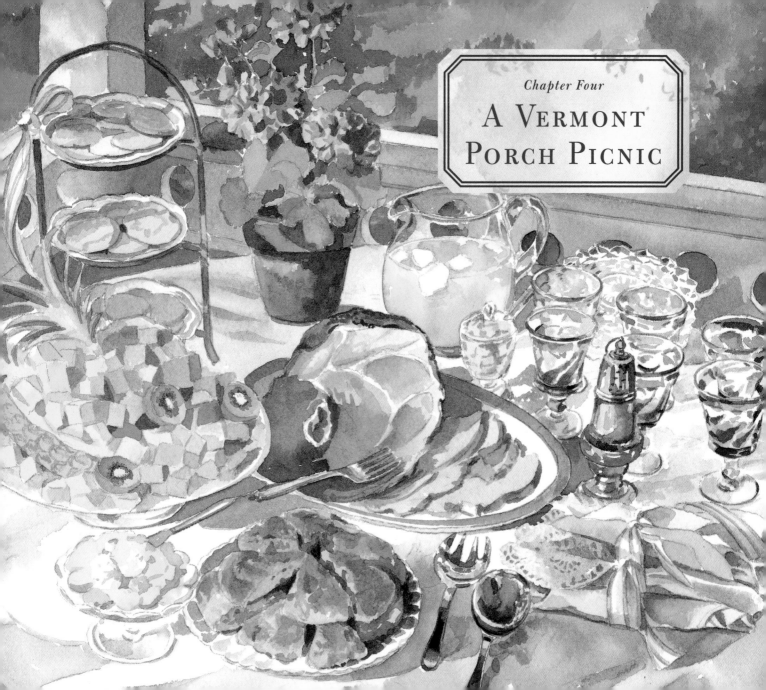

A Vermont Porch Picnic
A Leisurely Summer Brunch

Menu

VERMONT SMOKED HAM
Thin sliced and savory

·

PEAR-HAZELNUT SCONES
WITH GINGER BUTTER
An old favorite with a new twist

·

SEASONAL FRUIT
WITH POPPYSEED DRESSING

·

AUNT ALICE'S MAPLE
SYRUP SUGAR COOKIES
As delicate as sprigged china

·

ICED MINT TEA

Ah, Vermont. If I were blindfolded and secretly transported to this lovely place, I would know it the moment I opened my eyes. There is a look and feel to Vermont that is unique—blue-green mountains, white church steeples and charming town squares, front lawns seem to stretch out forever. And once you've tasted real Vermont maple syrup, breakfasts will never be the same.

For me, Vermont conjures up front porches filled with all the trappings of exquisite contentment—flowers, wicker rockers, an old-fashioned glider. One of the joys of searching for a rental house in Vermont is finding one with a front porch. Unexpected niceties happen on them. Neighbors come to visit. Tea is served in tall glasses. Screen doors snap. And conversations range from politics to local gossip. Porches are lovely on rainy days, especially for children. Filled with potted plants and white washed rattan, a front porch is the perfect setting for a picnic brunch—one that Frank Weston Benson's Eleanor would no doubt have adored. While *Eleanor* was painted in Maine and *Summer at Campobello,*

New Brunswick was painted in Canada, both express the leisurely mood of long summer days spent on Victorian porches.

‹ ❖ ›

Vermont Smoked Ham

These recipes showcase foods that are distinctly Vermont. Ham—yes, ham—is one of the delights. Vermont ham is quite different from a Virginia Smithfield ham, for it is cured in maple sugar and smoked with corncobs. This unique method results in a ham that is luscious, sweet, and easy to prepare. Simply pop the ham into a 300° oven with a bit of water and cook for approximately 15 minutes per pound, or until it registers 170° on a meat thermometer. Remove the ham from the oven and let it rest for half an hour. To serve, carve the ham into thin slices and heap on a large serving platter, leaving enough room for several small pots of assorted mustards such as dill, honey-cup, and Dijon. A bit of crème fraîche mixed into one of the mustards is a nice addition.

Pear-Hazelnut Scones with Ginger Butter

One of my favorite weekend jaunts to Vermont included a stay at a delightful bed and breakfast where guests were served buttery scones studded with pears from the tree in the yard. This recipe

SCONES

1½ cups pastry flour
1½ cups all-purpose flour
6 tablespoons sugar
3 teaspoons baking powder
½ teaspoon baking soda
4½ oz. cold butter
1 cup buttermilk
¾ cup pear, cored and diced
½ cup toasted, chopped hazelnuts
1 egg, lightly beaten

GINGER BUTTER

½ lb. sweet butter, softened
4 tablespoons chopped
 crystallized ginger

is a tribute to those scones, with the addition of an unusual ginger butter topping.

Combine dry ingredients. Cut in butter with pastry blender or put in food processor until mixture forms coarse crumbs. Stir in buttermilk just until it starts to hold together. Add fruits and nuts. Knead twice to form a ball. Pat out gently into two rounds, each about ½ inch thick. Cut each ball into 4 pieces and place on a greased and floured cookie sheet. Chill ½ hour, then brush with egg wash. Bake at 400° for about 20 minutes or until golden brown. Serve with ginger butter at room temperature. Yield 8 scones.

GINGER BUTTER:

Place ingredients in a blender and mix until creamy, though with bits of ginger still remaining.

Seasonal Fruit with Poppyseed Dressing

Visit a farm stand for an assortment of the ripest locally grown melons and strawberries and supplement these with mango, pineapple, and kiwi fruit. Slice the fruit and arrange on a platter surrounded by a wreath of mint leaves. Poppyseed dressing (available in your grocery store) works wonderfully with the fruit. Add about one hour before serving.

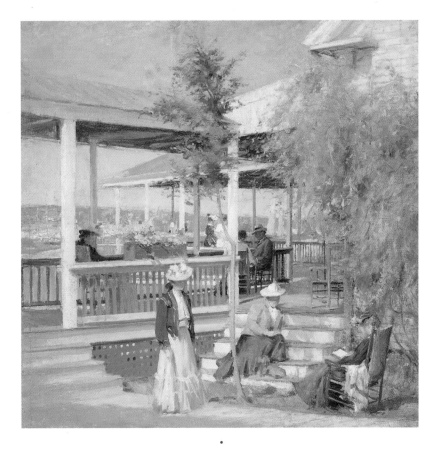

•

SUMMER AT CAMPOBELLO, NEW BRUNSWICK, *about* 1900
Edward Wilbur Dean Hamilton

1 cup sugar
¾ cup butter at room temperature
1 egg
2 tablespoons Vermont maple syrup
1 teaspoon vanilla
2 cups flour
½ teaspoon salt
½ teaspoon baking soda
Extra sugar in a small bowl

Aunt Alice's Maple Syrup Sugar Cookies

These delicate and delicious cookies are just right for a porch picnic, because they are so paper thin they wouldn't transport in a picnic hamper. But they're perfect when stacked on a beautiful china plate and carried from the kitchen to the porch. And their wonderful maple flavor makes a memorable ending for your picnic brunch.

Beat butter and sugar together until creamy, then mix in egg, syrup, and vanilla. Stir in sifted flour, salt, and soda. Refrigerate for 1 hour. Taking 1 tablespoon of dough at a time, roll into a ball approximately 1 inch in diameter, then roll the ball in sugar. Place the ball on an ungreased cookie sheet and press ball into a flat disk with the sugared bottom of a drinking glass. Allow plenty of room between cookies for spreading. Bake 8 to 10 minutes in a preheated 375° oven or until delicately golden brown around the edges. Makes 3½ dozen cookies.

Iced Mint Tea

Summers and porches always seem to lend themselves to freshly made iced tea. First, warm your china pot by filling with boiling water. Drain when heated thoroughly. Prepare strong tea using 2

to 4 teaspoons tea to each 8 ounce cup of boiling water. Place the tea in the warmed pot. Add 2 to 3 generous sprigs of fresh mint. Add freshly boiling water. Steep three minutes, then strain. Pour hot tea over cracked ice in tall glasses. If served in quantity, pour over a block of ice in a large pitcher. Iced tea cooled quickly is clearer and more sparkling than tea that is cooled slowly and then iced or chilled.

SETTING THE PORCH PICNIC SCENE

For this picnic brunch you have the advantage of going only from pantry to porch; nothing has to be squirreled away in hampers and carried to a remote picnic spot. So do yourself proud with the underpinnings! I suggest a turn-of-the-century theme in keeping with Benson's lovely *Eleanor*. Why not send antique postcards with the time and place, suggesting that the women dress in white and wear lovely period hats.

Drape assorted tables with sheets, allowing them to puff out at the bottom and tucking them under for a romantic look. Pots of geraniums can serve as centerpieces, and paper fans with each guest's name attached can make charming place cards. Spray

each fan with a bit of light scent, which will be released each time the fan sways from side to side.

 This is certainly the occasion to pull out all your favorite pieces of old china. If they don't match, all the better. Napkins can also be mismatched. To make an easy package for your guests to carry, roll the napkins around your silverware and then tie with ribbon. Use the same color ribbon and stack them in a colorful bowl; they will look charming.

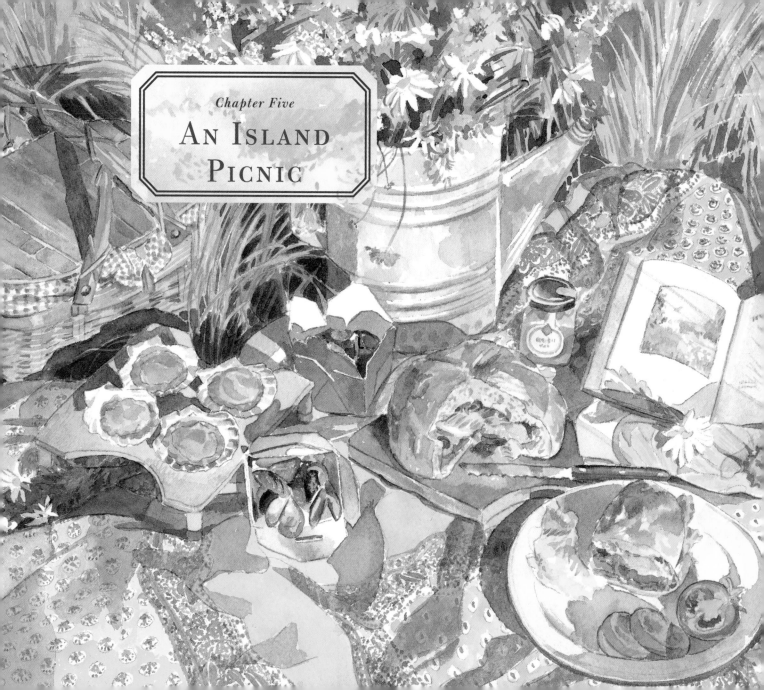

Chapter Five

AN ISLAND PICNIC

BATHING POOL, APPLEDORE, 1907
Childe Hassam

AN ISLAND PICNIC
Seabreezes and Summer Wildflowers

Islands have intriguing personalities, and New England islands have a lure all their own. There are islands like Martha's Vineyard, with its sandy beaches, secluded ponds, and talented artists and craftspeople. And then there are windswept, rocky islands like Appledore in the Isles of Shoals off New Hampshire, where a visitor will find, as did artist Ross Sterling Turner, magic of a singular kind. Turner was one of the many artists who gathered at the turn of the century at the island home of poet and master gardener Celia Thaxter. There they found beautiful music and stimulating conversation amidst a bower of flowers and vines.

The picturesque views afforded by an island make it an ideal picnic spot. Boats are usually available to ferry you to the island of your choice, either for a day or a long weekend. A particular delight of island picnicking is the anticipation you feel upon catching your first glimpse of that floating treasure.

→— ⊫⊨ —←

MENU

MUSSELS
IN VERMOUTH VINAIGRETTE
A mingling of herbs and the sea

•

MORGAN'S VEGETABLE
AND CHEESE TORTA
A fragrant layered sandwich
baked in its own bread shell

•

LEMON CURD TARTLETS
Garnished with island-gathered berries

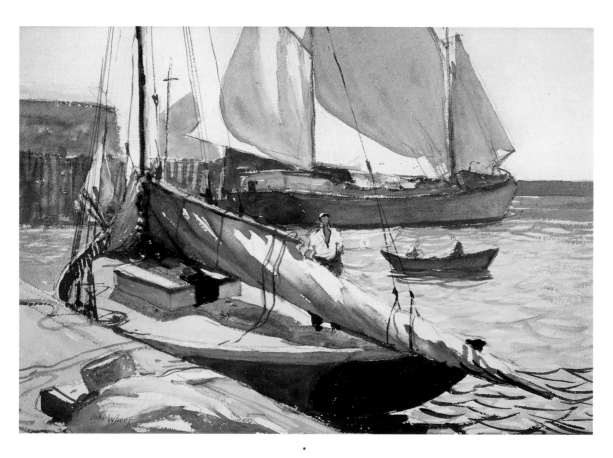

SAILBOATS
John Whorf

Mussels in Vermouth Vinaigrette

Whenever I am fortunate enough to devour a dozen or so mussels, I think of summers and beaches and friends. Rarely do you eat mussels alone; they are best shared with others and are very simple to prepare.

Whether you gather your own mussels or buy them, they need to be cleaned. Scrub each mussel and remove the beards. Soak cleaned mussels in a bucket of cold water for at least 2 hours. This should dislodge any sand.

TO STEAM:

Pour 1 cup dry vermouth or white wine into a large pot. There should be about 1" of liquid in the pot, so adjust if necessary. Add peppercorns and garlic and bring the liquid to a boil. Add the mussels and sprinkle with herbs. Cover tightly and steam for about 6 to 8 minutes or until the mussels just open. Discard any that have not opened and reserve liquid. Run mussels under cold water and remove and discard top shell. Chill for several hours.

THE VINAIGRETTE:

Strain reserved liquid, and pour into skillet and reduce. You will need about ⅓ cup for the vinaigrette. Place the oil and the mustard in a blender. Add the lemon juice and reduced mussel broth.

INGREDIENTS

STEAMED MUSSELS
4 to 5 lbs. mussels,
* cleaned and debearded*
1 cup vermouth or white wine
8 cloves of garlic, minced
12 peppercorns
4 tablespoons Herbes de Provence

VINAIGRETTE
1/3 cup reserved mussel broth
2/3 cup olive oil
2 tablespoons lemon juice
2 tablespoons Dijon mustard

Blend until smooth. Adjust any seasoning. Pour over chilled mussels and transport to your picnic, being sure to keep well chilled. Serve with wedges of sun-warmed tomatoes and crusty bread to sop up the delicious dressing.

Morgan's Vegetable and Cheese Torta

This is a dandy layered sandwich baked in its own bread shell. As it cooks, the flavors of the vegetables and herbs combine and the cheeses melt and mingle.

Sauté the onion slowly over low heat in 1 tablespoon olive oil (or spray pan with vegetable oil) until golden. Reserve. To roast the pepper, preheat oven to 425°. Place pepper cut side down on greased cookie sheet. Spray skin with vegetable spray. Roast until blackened. Remove from oven and cool to touch. Peel away charred skin. For this recipe, slice into strips. (You may want to roast extra and store in your refrigerator or freezer.)

TO PREPARE BREAD:

Slice off top ⅓ of bread and reserve for a lid. Hollow out bottom ⅔ to create a shell. Spread pesto over bottom and sides of bread shell. Layer ingredients in the following order: provolone, peppers, onions, artichoke hearts, feta, olives, Gouda, and basil. Drizzle a tablespoon or two of reserved artichoke marinade over

INGREDIENTS
*One 1-lb. round loaf of bread,
 not too crusty*
1 tablespoon olive oil
Vegetable oil spray
1 medium sweet onion, sliced
*1 large red pepper, cut in half
 lengthwise and seeded*
½ cup pesto
*¼ lb. smoked Gouda cheese,
 sliced thinly*
*¼ lb. aged provolone cheese,
 sliced thinly*
*1 jar marinated artichoke hearts,
 juice reserved*
*¼ cup feta cheese,
 drained and crumbled*
*¼ cup Kalamata olives,
 rinsed of brine*
*6 large fresh basil leaves,
 washed and dried*
*Assorted salad greens,
 washed and dried*

top layer. Cover with bread lid. Wrap in aluminum foil and place on cookie sheet. Bake at 350° for approximately 35 minutes, allowing the flavors to mingle and the cheeses to begin to melt. Cool in foil and carry to your picnic. Before serving, remove lid and add salad greens to fill to top. Replace lid and, using a serrated knife, cut torta into pie-shaped wedges. Serves 4 as an entree or 6 as an appetizer.

VARIATIONS:

Turkey and Gorgonzola are wonderful in layers as well. These two ingredients replace the peppers and Gouda.

Lemon Curd Tartlets

When I was a girl my best friend's grandmother would treat me to these tart delights every time I came to visit, which turned out to be quite often! As soon as I walked through the door she would head to the dining room to get the tin of tiny tart shells and then to the kitchen to retrieve the jar of lemon curd. After letting the curd warm a bit, she would carefully spoon great dollops of it into the fairy shells and hand them to the two waiting, greedy little girls. I'm happy to report that you can buy jars of lemon curd at the market, as well as tiny pastry shells already prepared and in

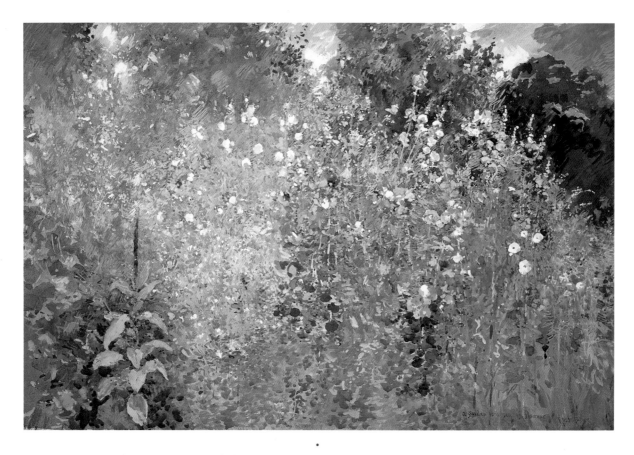

A Garden is a Sea of Flowers, 1912
Ross Sterling Turner

no need of refrigeration, both of which are perfect for your island picnic. Garnish with any ripe wild fruit.

SETTING THE ISLAND PICNIC SCENE

To do justice to a Celia Thaxter island picnic, flowers will of course will be central to the setting. Let's begin with the invitations: Press flowers from your garden and attach to the front of simple, white, folded cards. Invite your guests to an island picnic and ask them to bring a bouquet of their favorite flowers.

Bring a generous pitcher, vase, or old watering can to hold your guest's mingled bouquets. Weight the bottom with pebbles so your arrangement doesn't blow over in the island breeze. And do bring along a copy of Celia's book *An Island Garden* for browsing. Selecting appropriate napkins can be a challenge on a picnic. Some of my favorites are kitchen towels; they are large, absorbent, and wash up nicely. You can get them in beautiful floral patterns that work equally well for an island picnic or a party at home. Reserve a few of your guest's flowers so that after rolling up each napkin, you can tie with a flower, securing each stem in a loose knot.

Colorful Chinese take-out containers would be perfect to hold the mussels. A small cutting board is a must for cutting and serving the torta, and when it's time for dessert, simply flip it over to serve your lemon tartlets. 🧺

FOLLY COVE, *about* 1900
Philip Leslie Hale

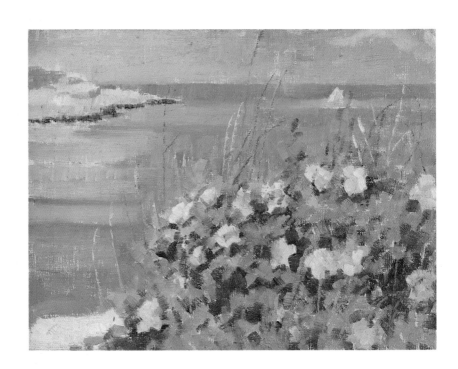

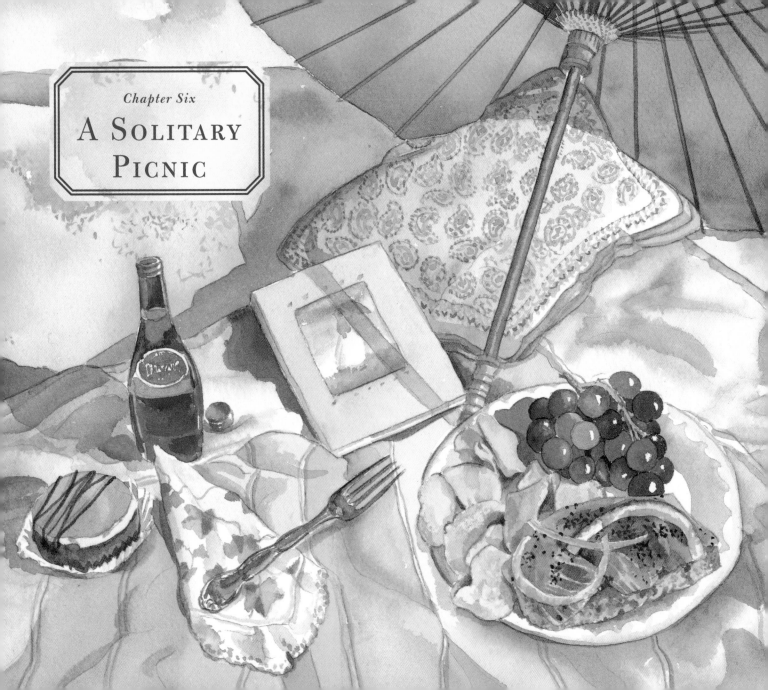

Chapter Six

A SOLITARY
PICNIC

A Solitary Picnic
Indulgences for One

Menu Ideas

Early Morning
Assorted biscotti & A bunch of grapes
A thermos of the best coffee you can find

·

The Spa Day
Several bottles of chilled mineral water
A mélange of excellent fruit and berries
A small portion of chèvre

·

A Lunch Time Ramble
Smoked Scottish salmon
on thinly sliced wheat bread
garnished with sliced onion and capers
Crisp vegetable chips
A rich pastry from a favorite gourmet shop

·

Teatime
A small camp stove
and kettle to brew fresh tea
Cucumber or radish sandwiches
Currant scones with sweet butter
A chocolate wafer candy bar

Beaches reveal nature's tidbits in the most delightful and intriguing ways. Mornings are my favorite time to meander along a stretch of beach; the sand has been washed of yesterday's adventures and new ones, yet to be discovered, unfold. Beach stones and tiny shells are my weakness, and they never cease to amaze me with their diminutive perfection. All too soon my hands are full, so I turn my attention to another favorite indulgence—finding a perfect spot to sit.

Rhode Island has hundreds of miles of coastline; let your mood determine where you wander. Near the mansions of Newport you'll find the Cliff Walk, with big jutting rocks where you can sit high above it all. The beaches near Little Compton offer a much quieter prospect, with driftwood benches tossed just so for a morning's sit. Still other beaches have hidden coves or configurations that promise hours of solitary pleasure. Whatever your choice, and wherever you are in New England, a pair of

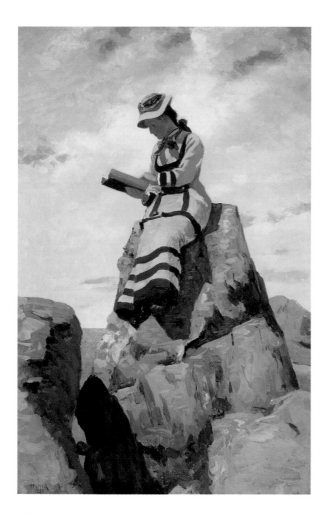

READING ON THE ROCKS,
GRAND MANAN, *about* 1877
John George Brown

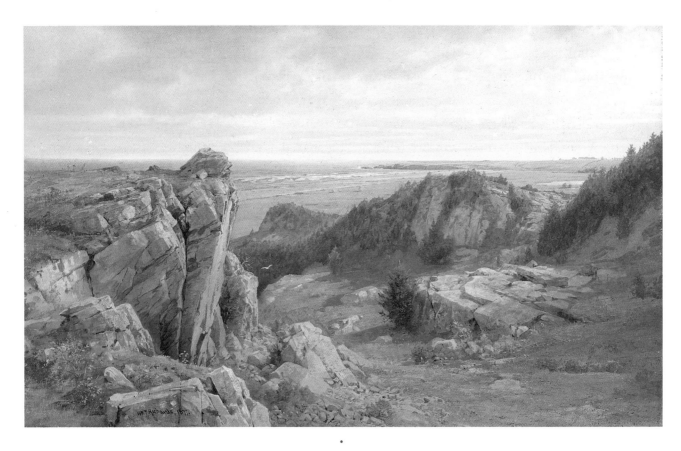

NEAR PARADISE, NEWPORT, 1877
William Trost Richards

binoculars, a favorite book, and a tasty lunch that leaves one hand free for reading are a must.

Since you have only yourself to please for this picnic, you can pick and choose among your favorite foods. Feel like a peanut-butter-and-banana sandwich with crushed potato chips? Indulge yourself! A hand-cut pastrami sandwich on freshly baked rye bread, accompanied by three—or maybe four—perfect half-sour pickles? Or perhaps you'd choose the ultimate indulgence—a small offering of Sevruga caviar, served on perfectly cut triangles of lightly toasted brioche, a split of champagne to be sipped with fresh blackberries and mangoes, dipped in lovely créme fraîche—not to be outdone by the double-dipped white chocolate truffles that you buy only for company but never for yourself. Once you enter into the spirit of imagining your favorite menu, your picnic will become a delicious gift to yourself.

SETTING THE SCENE FOR SOLITARY PLEASURES

Since this is a solitary picnic, you can be as free-spirited and indulgent as you wish. Consider packing a perfect little picnic basket and storing it in your car for those moments when you

want to treat yourself—or just need to be alone. Pamper yourself. Since you need only one of everything, pick up a unique or unusual basket, plate, silverware or picnic cloth in a local antique shop. Pack a small pillow, a Chinese lacquer umbrella, and a fabulous brimmed hat (also some sunscreen). To create a souvenir of your picnic, select a shell or beach stone that pleases you and write or paint the place and date of your picnic on it.

ROCKS AT NAHANT
William Stanley Haseltine

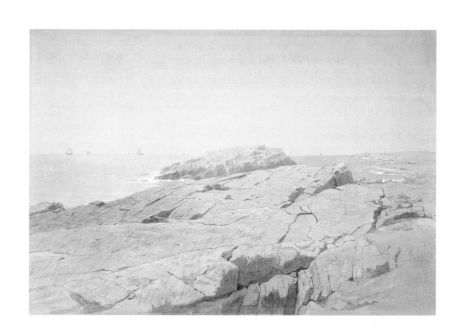

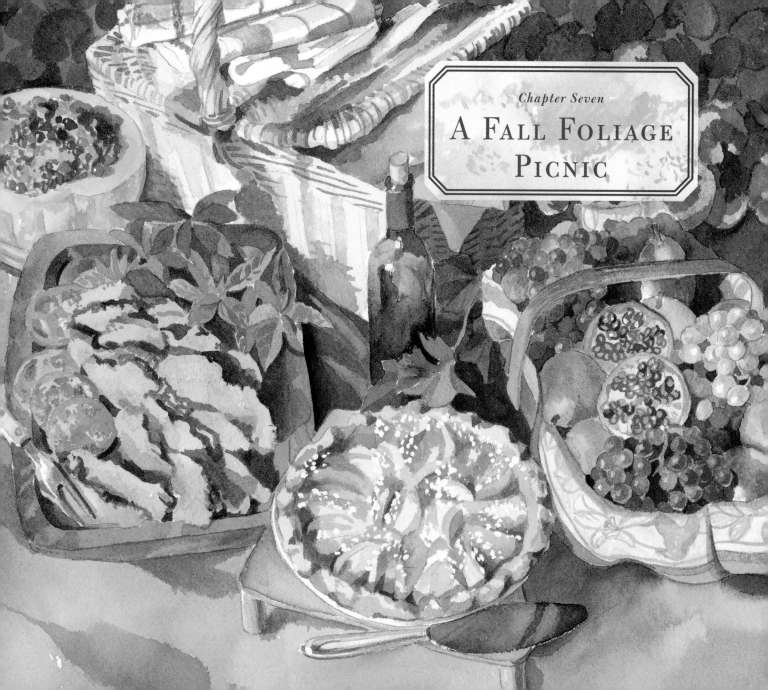

Chapter Seven

A FALL FOLIAGE
PICNIC

WOODS IN THE FALL
Childe Hassam

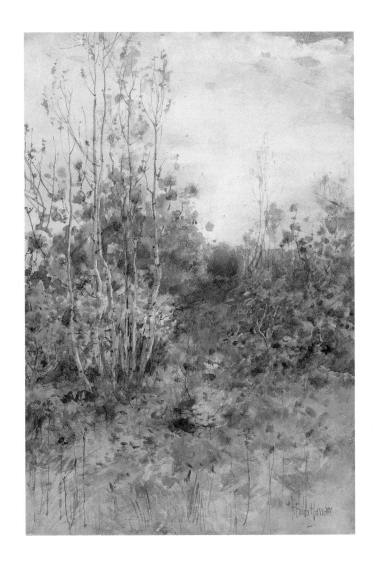

A FALL FOLIAGE PICNIC

A Feast for the Eyes and Palate

Nature outdoes herself come September and October in New England. The colorful plumage of maple, sumac, and birch would make a peacock swoon. Indeed, nothing is more visually rewarding than a foray into the countryside when autumn blooms. And there are so many ways to explore the colors of the season: A day trip by car, a foliage train or bus tour, or an airplane or balloon ride above the trees for a bird's-eye view of nature's caprice.

In New England the fall air is crisp—perfect for taking a walk through a meadow. Here and there an apple tree stands, still heavy with fruit, and cows graze in the mist-laden grass. If you are lucky enough to come by a pond you will be rewarded with yet another view of the season's magical colors, captured in its mirror of water.

Poet Robert Frost distilled the essence of autumn in New England when he penned: "Beguile us in the way you know. Release one leaf at break of day; enchant the land with amethyst."

MENU

GRILLED LAMB WITH PESTO MARINADE
To grill ahead or at your picnic site

•

CURRIED WILD-RICE SALAD
With cranberries for color and pine nuts for crunch

•

APPLE-APRICOT SUGARED TART
A delicately sweet confection

INGREDIENTS
4- to 6-lbs. trimmed
 and butterflied leg of lamb
1 cup basil pesto,
 homemade or store-bought
Olive oil

PESTO INGREDIENTS
2 cups fresh basil leaves,
 washed and dried
4 to 6 large garlic cloves,
 peeled and crushed
½ cup pine nuts
1 cup best quality olive oil
½ cup freshly grated
 Romano cheese
½ cup freshly grated
 Parmesan cheese
½ cup freshly grated
 Asiago cheese
Salt and freshly
 ground pepper to taste
Olive oil or vegetable spray
 for the grill

This simple lamb recipe can be made ahead and toted to your picnic spot, or it can be grilled on the spot. Buy a good quality lamb from your local market and ask your butcher to trim and butterfly it (remove the bone and flatten, leaving the meat attached in the center) so that each half is approximately the same thickness for even cooking.

TO MAKE THE PESTO:

Place the basil, garlic, and pine nuts in the bowl of a food processor. With the machine running, slowly pour in the olive oil until the ingredients are combined. Add the cheese and seasonings. Process until just blended. Makes approximately 2 cups.

Slather both sides of the lamb evenly with the pesto, wrap in plastic wrap, and refrigerate overnight. Bring to room temperature before grilling. Brush the grill with olive oil and cook the lamb over hot coals for approximately 10 to 12 minutes per side, or until medium rare in the thickest part. Let lamb cool before carving into thick slices and packing, or for an at-home dinner carve and serve immediately.

Serves 8 to 12.

Curried Wild-Rice Salad
with Dried Cranberries and Pine Nuts

The cranberry bogs of New England are famous and the tart berry, once synonymous with Thanksgiving and sauce, is now turning up in the most delicious of places. A handful of dried cranberries tossed into a summer salad of greens is a tangy surprise, and a vanilla ice-cream cone dipped into a bowl of dried cranberry sprinkles is a delight. And this wild-rice salad with its nip of curry makes a nice destination for our plumped berries.

Prepare wild rice and while still warm, pour vinaigrette over rice and mix. Blend curry powder into mayonnaise and add to rice mixture, folding to combine. Poach the cranberries in vermouth until plump. Cool in liquid and drain. Fold into rice mixture, along with pine nuts.

To serve, press into a Teflon-coated mold, chill, and unmold—or mound into a colorful, hollowed-out squash.

INGREDIENTS
4 cups cooked wild rice
* or a mixture of white and wild*
½ cup mayonnaise
½ cup vinaigrette dressing
¼ to ½ teaspoon curry powder
* (or to taste)*
1 cup dried cranberries
¾ cup dry vermouth
¾ cup pine nuts
(Note: sauté pine nuts
in a scant teaspoon of oil
in a heavy-bottomed
skillet until golden)

INGREDIENTS
1½ cups all-purpose flour
1 pinch salt
4 tablespoons sugar
1 stick sweet butter, sliced
2 large egg yolks
1 lemon rind (zest only), grated
3 to 4 cooking apples,
* peeled and sliced thinly*
1 12-oz. jar apricot preserves
Confectioners' sugar

This is without a doubt one of the most wonderful desserts I have ever eaten. The sweet pastry can be a bit tricky, but is well worth it. With its blend of apple and apricot flavors, this tart is the perfect autumn dessert.

In the bowl of a food processor, mix flour, salt, and sugar. Add butter and pulse 3 to 4 times until the mixture is coarse. With the machine running, add the yolks through the feed tube and process until the mixture forms a soft ball. If the mixture seems too moist, add a bit more flour and repeat process. Flour your hands and remove the dough. Flatten into a large disk and wrap with plastic wrap. Refrigerate for an hour. Before assembling the tart, let dough stand at room temperature for 15 minutes. Flour a pastry cloth and rolling pin (re-flouring when necessary) and roll dough into a large circle. Transfer to a 9-inch pie plate. If the pastry tears, don't worry, just press together with your fingers. Flute the edges. Add the sliced apples in a spiral fashion and spread the preserves evenly on the top. Bake in a preheated 425° oven for 15 minutes. Reduce heat to 350° and bake another 30 minutes. Remove from oven and sprinkle with confectioners' sugar. Serve warm or at room temperature.

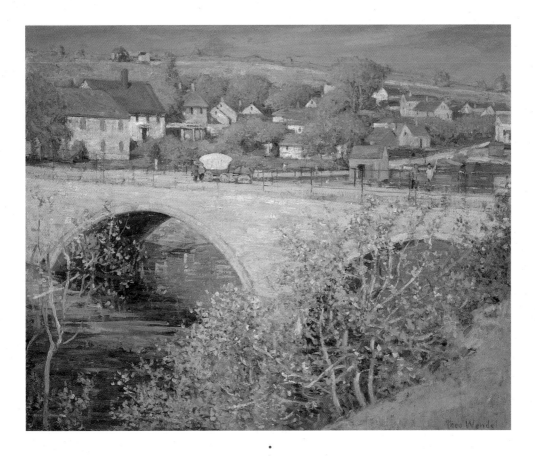

BRIDGE AT IPSWICH, *about* 1905
Theodore M. Wendel

SETTING THE FALL FOLIAGE SCENE

Create your picnic decor around the amazing colors of fall. A centerpiece for your picnic cloth can be a simple but opulent gathering of grape clusters, persimmons, pears, apples, nuts, and leaves arranged in an artful pile on a lovely platter. Colorful paper leaves, available in kitchen shops, add a nice touch of color and whimsy to serving plates. Put 2 to 3 on each dessert plate and top with a slice of apple tart. Your curried wild-rice salad can be served in a hollowed-out pumpkin or large squash, and the grilled lamb can be displayed on a large wooden cutting board with a bouquet of basil set just to one side. Present each of your guests with a disposable camera and ask them to take their favorite foliage photos as a remembrance of their picnic day.

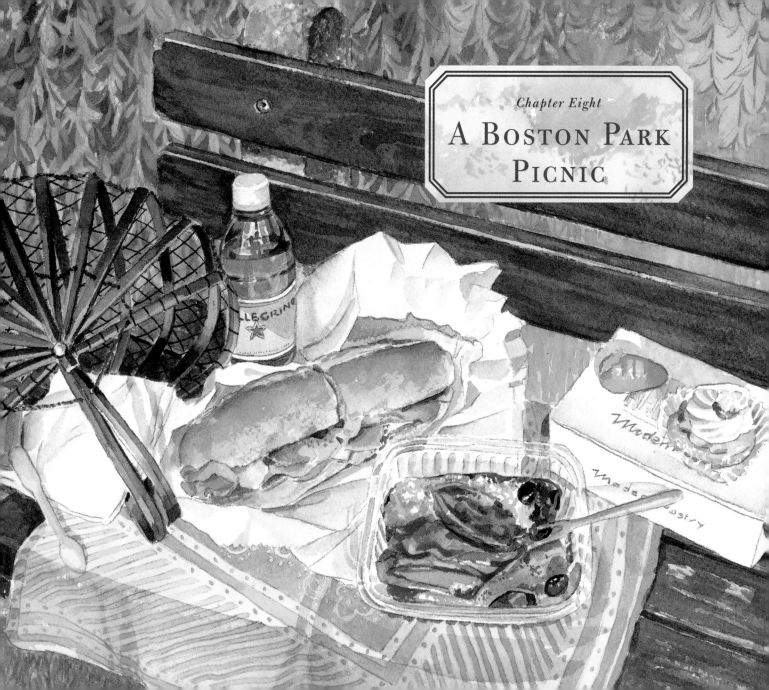

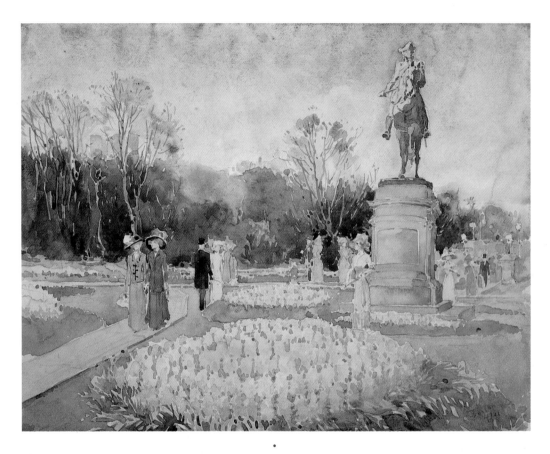

BOSTON PUBLIC GARDEN, 1910–1915
Artist unknown

A BOSTON PARK PICNIC
For City Dwellers and Visitors

If you picnic in Boston's Public Garden, the hubbub of the city will quickly recede and you will be enveloped in the visual delights of the circa 1859 botanical garden. All gateways and paths into the garden meander to and around the lagoon, famous for its charming swan boats and its ever-present and ever-hungry ducks. There are benches galore, each with its own vista of ornamental plantings, exquisite fountains and statues, and of course the remarkable collection of trees that grow and bloom and paint the garden with their color and texture. My favorite spot is at the edge of the lagoon, under a weeping willow, watching the swan boats glide by.

The beauty of an in-town picnic is that you can make a pre-picnic foray into some of Boston's exciting and aromatic neighborhoods—the Italian North End and colorful Chinatown are two—and come away with glorious, already-prepared picnic fare. Each neighborhood is only a subway ride away from the Public Garden. Or within blocks of your picnic spot, along the

MENU

ITALIAN NORTH END
Marinated artichoke hearts, olives,
fresh mozzarella, roasted peppers,
and roasted eggplant
A sub or panini of cold cuts and cheeses
Assorted pastries, marzipan
Italian mineral water

•

FARMERS MARKET
A crusty baguette
with a locally made goat cheese
topped with sliced tomatoes and basil
The best, ripest fruit of the season,
perhaps a peach picked that morning.

•

CHINATOWN
Crispy duck salad with sesame dressing
Fresh spring rolls with shrimp
A Chinese pear
Thai iced coffee

historic thoroughfares of Charles and Newbury Streets, you will find other gourmet take-out stores to tempt you.

<center>· + ⊨⊟ + ·</center>

Setting the Town Picnic Scene

While a town picnic can be fun to plan, it is perfect for that spontaneous moment when the sun appears out of nowhere and you are struck by the urge to dine alfresco instead of at your desk. You can enjoy an impromptu but elegant picnic by storing a kit in your car or office. Large square cotton scarves make ideal picnic cloths and they wash up nicely. For tableware that is colorful, light, and portable, try enamelware—there are so many bright patterns to choose from. Napkins? Choose paper guest towels that you would normally use in your bathroom. They are large, absorbent, and come in great patterns and colors. Silverware? Mix-matched silverware is fun, and local antique shops often have inexpensive silverplate pieces for just a few dollars. A bit of silver polish can do wonders. Don't worry about mixing patterns, picnics should be gypsy-like, anyway. And for a hamper, store everything in a colorful string bag that leaves plenty of room for your take-out picnic fare.

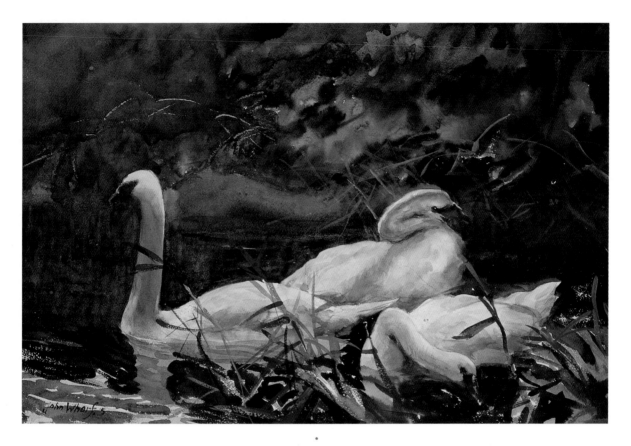

Swans

John Whorf

Illustration Credits

Recipe Index